Simple
Pleasures

Simple Pleasures

Life's Little Joys

Clare Gogerty

National Trust

Contents

Introduction

It can be easy to forget that the most precious and rewarding pleasures in life are the simplest. They are not measured by money or governed by social status, often they are not especially significant, but frequently they are the most wonderful. Caught up in the hubbub of to-do lists, chores, family and work demands, we can lose sight of these magical moments. Fortunately, they are readily available, sitting unprepossessingly under our noses, waiting to be called to action.

The joy of these simple pleasures is that they can be found amid the humdrum business of daily life. It can be the unexpected joy that arises when hanging a line of washing on a breezy spring morning, or the deliciousness of biting into a warm slice of buttery toast, or the sybaritic pleasure of a long hot bath. Nature is a constant and reliable source of mood-boosting pleasure, from the simple task of planting a seed or watching leaves caught in the wind to the thrill of seeing a bird of prey wheel in the sky. Joy comes from other people, too – unbridled laughter, chatting into the night, being cooked for – as well as from your own company and the peacefulness of taking time out.

'Simple pleasures are the last healthy refuge in a complex world.'

OSCAR WILDE

The National Trust, with stretches of coast, countryside and buildings under its care, is a repository of these simple pleasures. Visit any of its sites and be open to what you might find there. It could be a magic moment caused by the rhythmic rattle of pebbles being shunted by the sea on a shingle beach, the sound of the wind through the leaves of an ancient forest, the bountiful produce in a vegetable garden or the view from a window in a grand house.

This book has 100 examples of simple things that give me pleasure. Every one is so easy to experience that it's a wonder we don't actively seek them out all the time. The trick is to remember they are there and take the time to appreciate them properly – they can be fleeting, so to experience them fully, they need to be savoured and noticed. Once they are, more will appear, and you will notice that your life is more magical and filled with more pleasure than you ever imagined.

Clare Gogerty

The comforts of home

Many of life's most
satisfying moments can
be found within your
own four walls.

1 Pyjamas warming on a radiator

Few things are as promisingly cosy as the thought of pyjamas warming on a radiator. There are times when I am engaged in some moment of domestic need – unloading the dishwasher, say, or sorting mismatched socks – when the thought of that cosseting treat-in-waiting speeds me on to the luxury that awaits. This also works post-bath: slipping into warm pyjamas after a long soak is not to be belittled.

2 Listening to podcasts in the bath

The self-indulgent benefits of a hot bath cannot be exaggerated. Few other things have the power to induce an involuntary sigh of pleasure in me as a tub filled to the brim with scented bubbles. Especially when there is no immediate hurry to get out, and hot-water top-ups enable a good, long soak. Once eased into the comforting warmth, the sybaritic experience rises another notch with the introduction of sound. Listening to a favourite podcast, music playlist or radio programme in the bath gives it the attention it deserves. The door is firmly shut. There are no other members of the household making demands, no chores to attend to, no animals clamouring to be fed. Just me, the bath and whoever I have chosen to fill my head with stories, ideas and music.

> 'The true secret of happiness lies in taking a genuine interest in all the details of daily life.'

WILLIAM MORRIS

3 Clean windows

There are those who think that cleaning windows is an act of drudgery, to be endured or outsourced to a window cleaner, but I would disagree. It is a task to savour. To start, there is the generally transformative power of cleaning: what was once grubby is now pristine. And I have made it so. Then there is the eye-opening clarity that comes as a result: like a trip to the optician after months of ignoring a faulty pair of glasses. The outside world pings into glorious high definition. The rosemary bush in the garden, once an obscure, shadowy form, is now revealed as a spiky thing adorned with purple flowers. Different species of birds can be identified on the feeder; clouds are spotted in all their varieties scudding above the neighbour's shed. The sun shines brightly through the squeaky-clean, smear-free panes, illuminating all within. My world comes into focus; it is brighter, crisper, happier.

4 Anything toasted, preferably buttered

It is one of life's greatest joys that the easiest food to cook is also the most delicious. Culinary alchemy occurs when a slice of bread is inserted into a toaster. What was once a limp, pale slice becomes a warm, crusty base on which to slather butter. Further joy occurs as the butter instantly melts, creating an unctuous coating that will very likely drip down your chin and need to be wiped away with a napkin (or your sleeve if no one is looking).

The life-enriching toast effect is due to a chemical process (called the Maillard Reaction after Louis-Camille Maillard, the French chemist who discovered it). Basically, this is the reaction between amino acids and

sugar as the bread is cooked, producing new molecules which change its colour, smell and flavour. For which explanation, science, we are grateful.

Toast is elevated to even higher glories when it becomes a toastie. Here, the toasting process not only transforms two slices of bread but also the contents within. Thus, cheese becomes gloriously oozy, in contrast to the crunch of its toasted shell. The French have further elevated the toastie to dizzying heights with the croque monsieur* (which involves ham, Gruyère or Emmental cheese and sometimes béchamel sauce) and croque madame (topped with a poached or fried egg).

Bread is not the only thing that is magically transformed by toasting. Give me a pale, tasteless crumpet, a toasting fork and an open fire, and in return I will give you a crunchily topped platter conveniently cratered to absorb massive quantities of butter and honey. (With the added benefit of creating a nostalgic 1950s-bedsit-type vibe.) Likewise, a toasted, buttered, jam-loaded, richly fruited bun – a largely unnecessary teatime treat and all the better for it – is a divine interruption to a miserable winter afternoon.

* It is even mentioned by Proust in *In Search of Lost Time*, 1913. The first time it appears in literature but surely not the last.

5 Finding chocolates you'd forgotten you had

You are rooting about in a cupboard, looking for something quite else, when you come upon them. A box of unwrapped, undisturbed (and, most importantly, uneaten) chocolates. A present perhaps from a relative at Christmas that has (until glorious now!) lain forgotten. A bonus treat sent from the chocolate gods. Praise be.

6 Slippers

Oh, the sublime comfort of slippers. What other footwear offers such ease? They are surely the friendliest, most accommodating of shoes. No cramped toes or need for plasters with these lovelies. Slip on a pair and you enter a world of warmth, forgiveness and kindness. Slippers say 'home' like no other item of footwear. They signify the contentment that comes from kicking off my shoes as I get in, shutting the front door and having no intention of going out for a very long time. They are my go-tos first thing in the morning, cocooning my feet as I make the cruel transition from warm bed to chilly bathroom floor. And they are versatile, enabling me to pop outside to put the bins out or snip a few herbs without changing into actual proper shoes.

There are several theories about the invention of slippers but my favourite is that they originated in France, where they are called *pantoufle*. In the 17th century, servants wore shoes made of felt off-cuts, known as 'silents', to pad discreetly around their masters' bedrooms without disturbing them. And so the *pantoufle* was born. These days, we can enjoy the cosiness of a sheepskin bootee, the stylish comfort of a felt mule, or the wraparound snugness of a suede moccasin. It is rare to find a sexy slipper (unless you opt for a fluffy high-heeled mule, perhaps) but, really, who needs sexy, I say, when you can pad around comfortably, toes unrestrained, slurping a cup of tea in your joggers?

'Happiness is in the quiet, ordinary things. A table, a chair, a book with a paper-knife stuck between the pages. And the petal falling from the rose, and the light flickering as we sit silent.'

VIRGINIA WOOLF

7 Clean sheets and a plump duvet

There comes a time in everyone's life when staying up late loses its appeal. The lure of going to bed starts to have a far greater pull. The thought of crawling under a plump duvet, laying a weary head on a crisp, cool pillow and drifting peacefully off to sleep between fresh sheets far outweighs any lingering desire to hang out and party. I consider the day I first bought decent bedlinen as the day I made the transition from youthful grubbiness to adult sophistication. A matching duvet and pillow set was bought at Habitat as I moved in with my then-boyfriend. Trying hard not to be too girly, I shunned the floral sprigs and went for light-blue, denim-look cotton. A cunning compromise between feminine flowery and 'man' bedding, which at that time was mostly dark brown and beige. It was a success. The boyfriend announced that since I had moved in life had become more civilised and he no longer had to 'sleep on a stained cot' (he was a poet harbouring romantic notions).

From then on, there has been no stopping me. I love bedlinen in all its gorgeous varieties and cannot resist buying the stuff. One of the reasons I bought my current house was that it had a linen cupboard: a place to store folded sheets and surplus pillows is one life goal I have managed to achieve. As the years have rolled on, my fixation has become more expensive, with thread counts

increasing and tog rates rising. It's worth the financial outlay: with better bedding, comes a better night's sleep. Freshly washed sheets (preferably smelling sweetly after being dried on a washing line outdoors, see 19) are the gateway to an untroubled night. The tiresome business of removing a duvet cover, laundering it, and then, groan, putting it back on, is ameliorated by the divine comfort of slipping into clean bedding. I even iron it (an activity that appals many friends), aware that creaseless sheets elevate bedtime way beyond any crumpled, student-house-share associations into responsible adulthood.

8 Learning to cook a new dish

It can be difficult to resist 'default' meals – those tried and tested dishes that can be cooked with barely a thought. (My two 'signature' dishes are spaghetti carbonara and corned beef hash. I have no shame.) Sometimes, though, a recipe in a Sunday supplement or an enticing new cookbook calls. Often you need a generous amount of time to do justice to it: hurrying it will diminish the pleasure. But mastering a dish that is a little beyond your usual repertoire or requires learning a new skill (shortcrust pastry! salsa verde! toasting spices!) is a delight in itself. The fact that you can eat the result doubles the pleasure.

9 Year-round fairy lights

The pleasure of fairy lights at Christmas is a given: no one doubts their power to bring twinkling magic into the darkest time of year. This cable of pretty bulbs transforms the gloomiest corner into something delightful, puncturing gloom with shimmering, winking light. But why restrict them to the festive season? Last year, rather than pack them away on Twelfth Night, I left them out. Now they festoon the yucca plant in the living room, transforming what was a dreary corner into a glittering grotto. In the garden, outdoor solar lights draped on a pergola turn a humdrum patio into something enchanted. Such is their year-round bewitching power.

10 Sorting out a cluttered cupboard

Finally, all those days of rooting about among forgotten cans and half-used bags of rice as you try to locate the mustard are over. You have taken the time to 'Get Things Sorted'. Everything has been decanted on to the floor. Surplus, decrepit or out-of-date items have been dispatched. Shelves have been washed. The surviving items have been reintroduced into the cupboard in an orderly fashion. You have got it together. You are amazing.

11 Making tea in a teapot

Dunking a tea bag in a mug full of just-boiled water is an activity many of us undertake countless times a day with barely a thought. Anyone who has worked in an office knows this only too well: most workplace kitchens have walls streaked with tea from tea bags carelessly chucked towards the bin post-dunking. But it's not a whole lot harder to put that same tea bag in a teapot, let it brew for a minute or two, and then pour. In every office I have ever worked in, I have always insisted that tea is made in a teapot, and come equipped with a Brown Betty*. Which probably makes me an immensely irritating co-worker. The results are worth any flack, however: an immeasurably better cuppa – often enough for a refill if

the pot is big enough. Plus, there is no need to squish the tea bag against the side of the mug with a spoon before flinging it at the bin. Use loose tea rather than tea bags and the experience is heightened further: you actually begin to appreciate the flavour of the tea. You start to differentiate between Assam and Darjeeling. You buy china cups. You pour milk from a jug rather than straight from the bottle. You start smelling packets of tea and sighing. You never dunk a tea bag again.

* A large earthenware teapot with a brown glaze (best for retaining heat), for those not in the know.

12 The crackle of a log fire on a cold night

The sound of a log catching light is guaranteed to warm the heart as well as the home. As the flames flicker into life, the room is filled with two of life's essentials: heat and light. The fireside is a place to gather, to warm your feet, to hold out your hands towards the flames. People look better in the soft light of a fire as the flames' reflections are caught in their eyes. The atmospheric crackle of a fire is caused by pockets of trapped water and tree sap starting to boil and turn to gas. The more water and sap inside the wood, the noisier the fire will be. There is a downside to this, unfortunately: the particulates from wet wood, especially if burned

in an open fire, are polluting both to humans and the environment. Make sure the wood is thoroughly seasoned (i.e. has dried out) to maximise your pleasure.

13 A mug of hot chocolate after a long walk

A good long walk – one that involves walking boots, a rucksack, a map, a compass and a packed lunch – deserves a proper reward. As I approach the end of a day's walking, my thoughts inevitably turn to refreshment. This is often the subject of a lively discussion with my fellow walkers. What shall we choose? A pint and a sandwich in a country pub? A cup of tea and a piece of cake in a café? No, best of all, I insist, is a mug of hot chocolate, topped with a swirl of cream. It is an indulgent mug of velvety richness, and perfectly justifiable – guilt-free calories! – after all that walking.

14 The smell of coffee

Catch the aroma of coffee as you walk along the street and your nose will irresistibly follow the olfactory trail to its source. Before you know it, you will be placing your order for a flat white or similar, impatiently anticipating the caffeine hit to come. The smell of coffee, especially roasting beans, is one of life's most bewitching

and complex aromas, which is why I keep a cafetière on the go for most of the day. It's not just the taste we crave but the accompanying smell, which is created by hundreds of different compounds reacting with proteins and sugars. This causes an actual physiological response as it wafts from nose to brain stem and on to the limbic system, which controls emotions and memory. Put simply, the smell of coffee makes us feel good. Resistance is futile and pointless. Why would anyone deny themselves this pleasure?

15 The first mince pie of the year

The first mince pie of the year is a welcome harbinger of Christmas. Best, however, to resist those packets of six in seasonally themed boxes when they first appear in the supermarket. You don't want to go in too early.* The best approach I find is to wait until December and make a batch yourself. A mouthful of warm shortcrust pastry and sweet, spicy dried fruit, dished up with whipped cream, is a microcosm of Christmas; an appetiser of the many treats to come. (Flaky pastry is becoming more commonplace but I prefer the firmness of shortcrust as a contrast to the stickiness inside.) The smell of a batch of mince pies baking makes them even more irresistible. My mother would cook a dozen or so in the run-up to Christmas,

squirrel them away in a cake tin, hoping they would last the season, only to find my dad couldn't hold out and had eaten the lot.

Mince pies have not always been sweet or seasonal, however. They were first cooked in the Middle Ages when the pies were packed with chopped meat, sturdily constructed and big enough to feed several trenchermen. Their purpose then was to preserve meat in a pastry case, not to provide additional festive sweetmeats. Over time, fruit, spices and sugar were added, and they became associated with Christmas festivities: Samuel Pepys had a batch delivered for Christmas when his wife became too ill to make them. By Victorian times, they were commonplace; Mrs Beeton had a recipe for a

meat-free one in her *Book of Household Management*. We haven't stopped eating these precursors of Christmas since and I for one am jolly (ho ho) grateful.

* The same reasoning applies to the first Creme Egg of the year, although it is hard to wait until March or April, as their official release date is January (coming off sale post-Easter).

16 Reading in a favourite armchair

It is a simple enough activity: sitting in a favourite chair long enough to read a book. Why, then, is it such a rarity, such a treat? Perhaps because we think of reading as an indulgence when, actually, it's a necessity. The joy of devoting time to the straightforward but rewarding business of reading cannot be overstated but is actually hard to do. Life, and people, get in the way.

The right choice of armchair, however, enables this. Mine is the sort that envelops me in its ample upholstery so comfortably that it's hard to get out without a struggle. It is the definition of 'snuggly', and the place to curl up on a wintry day with a book and a cup of tea as rain patters on the window.

Another way to achieve 'reading space' is to create a designated area – a reading nook. All it needs is that armchair to curl up in, a pool of light to sit in, and

a shelf or pile of books by your elbow, waiting to be read. This 'nook' signals to household members that you do not want to be disturbed, thank you. Then you can comfortably and guiltlessly lose yourself in that book you have been wanting to read for ages but simply haven't had the time.

17 Supper on the sofa

If, like me, you grew up in a house where every meal was eaten at the table, you will understand the simple appeal of eating on the sofa. It feels a little bit rebellious, a little bit decadent. It is certainly a treat. You enter a world of ease where seating is slouchy, and conversation consists of pointing at the TV with a fork and grunting. Certain foods work better than others. Pizza is good, allowing the freedom of eating with no cutlery at all, although ice cream eaten with a spoon directly from the tub works too. Supper on the sofa is also when the coffee table, piled high with drinks and supplementary snacks, comes into its own. The only thing that spoils this indulgent feast is wondering who will clear the pile of dishes and empty boxes once you have sunk back into the sofa, replete and snoozy.

18 A rocking chair

Of all the furniture I have ever bought, the rocking chair has consistently delivered the most pleasure. Mine is wooden, a bit creaky and has a nice high back. It sits in a corner of the kitchen and is where I sit to take off my shoes, read any post and, most frequently, just nudge myself back and forth and daydream. A rocking chair is built for rumination. As it tips backwards, the gaze of its occupant drifts upwards, and a dreamy, stare-at-the-ceiling posture is enforced. It is the ideal angle for a spot of musing. The swaying motion is also deeply soothing, resembling the movement of a mother's arms as she rocks her child to sleep. President John F. Kennedy owned 14 rocking chairs, including one in the Oval Office, which he rocked on to ease his back pain. It is an essential piece of furniture, especially for daydreamers and presidents.

19 Pegging out washing in the garden

Hanging out washing is that rare thing: a pleasurable household chore. It's a breezy sunny morning, you have a laundry basket full of freshly washed clothes and a bag of pegs. Off you go into the garden, feeling industrious and a little bit noble as other household members loaf about inside drinking coffee. This pleasing, methodical task gets you outdoors

and offers a few moments alone, to think. In my garden, the washing line extends across the lawn from the house to a tree, propped up midway with a rickety wooden pole. Nothing (domestically) pleases me more than pegging out white cotton sheets, then seeing them billow in the breeze, knowing that soon they will be dry. They will also smell amazing. The scent of line-dried laundry is hard to pinpoint (many washing powder and scented candle companies have tried) but irresistible: it will have you burying your nose in the laundry and inhaling deeply before you know it.

The uplifting outdoors

A myriad of
mood-boosting
pleasures lies beyond
the front door.

20 A blooming window box

What I love about window boxes is their generosity and friendliness. They are displays intended not just for the occupiers of the house, but for the whole street. They gladden the hearts of passers-by with their colourful blooms and trailing ivy. Whether they are a row of bright red geraniums, a collection of winter pansies or a more complicated arrangement involving seasonal planting and grasses, they seldom fail to cheer. The front of a house feels naked without a window box, especially in a city. It can be the only

opportunity to grow something; your little patch of earth to cultivate. Every house I have ever lived in has had one. In truth, these have varied in quality and success. The one on the balcony of a block of flats was blasted by wind and rain, and its withered contents struggled to survive. Outside a terrace house in London, the plants in my trendy galvanised metal window box grew more successfully, when I remembered to water and feed them. Now I have two outside my house in the country which are better cared for and bring me a small burst of pleasure every time I come home. There they are, either side of the front door, pushing out leaves and flowers, brightening my day and, I hope, everyone else's who walks past.

'Beauty is the single glimpse of green, in sunlight however dimmed, in clouds however darkened, in faces however worn.'

OCTAVIA HILL

21 Falling autumn leaves caught by the wind

The change of the seasons is marked in many different ways. My favourite signpost that summer is ending, and autumn is almost here, is the first fall of leaves from the silver birch at the end of the garden. Watching its mustard-coloured leaves drop from the branches, get caught by the wind as they are backlit by sunlight, then twirl and tumble to the ground is a truly joyful thing.

22 Bringing flowers into the house

It's with a real sense of accomplishment that I cut flowers from my garden, gather them up and then display them indoors. 'Look what I've grown, everyone!' I think (and often say) as I proudly place a few daffodils in a jug. My ambition is to one day create a cutting garden with a variety of blooms to choose from and arrange artfully in huge vases indoors. (This dream has been fed by watching too many films set in stately homes when the lady of the house comes tripping in from the garden with a trug filled with long-stemmed flowers.) Until then, I will make do with my cheerful bulbs and annuals, or head out for a spot of sensitive wayside foraging. Only picking a few blooms and taking care not to damage any remaining. A few stalks of cow parsley – with its delicate white flowers and fern-like

foliage – arranged in a tall container is a bold celebration of nature, brings a little of its wildness indoors and you don't need a garden to enjoy it.

23 Standing beneath an oak tree in the rain

Any time spent beneath a tree is well spent, but under an oak especially so. Up the lane near my house is a particularly venerable one. It stands on its own at the edge of a field, where it has stood for centuries most likely. Some solitary trees were planted as 'witness trees', a term meant originally to mark boundaries but which has come to mean a tree that has seen many things – a repository for the past. I like to think of this oak as a witness tree that could tell many tales. As I walk towards it, it greets me with open arms – oaks generally grow sideways in an expansive and friendly fashion. It is especially welcoming when it's raining. There are few better places to shelter than under an oak tree. In the summer, its generous canopy provides plenty of cover from rain* (and sun), as well as a habitat for birds. I can watch the rain fall all around and birds fly in and out of its boughs as I lean against its furrowed trunk, protected by its branches until I am ready to set out again.

* Soft summer rain is the best sort of rain, settling the dust, reviving the soil, refreshing the rambler.

24 **Going outside without a coat**
There are few days in the UK when you can leave the house confidently knowing that a coat will not be required. These are the freedom days when you can skip to work, the shops or wherever, unencumbered by outer layers, and as such they are to be cherished. (Another day to celebrate is the first time the sunglasses come out, especially after a gloomy, sun-deprived winter. I always greet mine like an old and valued companion. 'Hello, old friend. *There* you are.')

25 **The smells of summer**
A walk in a park on a summer's day is a treat for all the senses, including the least appreciated: smell. Stroll beside a rose bed in full bloom and you will get a noseful of its heady scent. Barbecues fill the air with the taste-bud-tingling smell of grilled food. A leaf of an aromatic plant or herb rubbed between finger and thumb smells delicious. The suntan lotion you applied earlier gives up its coconutty fragrance. The scent of freshly mown grass is the essence of summer itself. Interestingly, smells are more potent during the warmer months. This is because they are affected by temperature: the warmer or more humid the air, the more aromatic molecules it can hold, and the more quickly and freely they move around. In cold air, the

molecules move slowly. Which is why the park (or any other outdoor space) is a summertime treat for the nose and the spirit.

'Enjoy the little things in life ... for one day you'll look back and realise they were the big things.'

BEATRIX POTTER

26 Watching the full moon rise in a cloudless sky

Little is as guaranteed to give me the shivers (in a good way) as a full moon. Especially when it catches me unawares, rising behind a tree or glimpsed unexpectedly as I draw the curtains. Seeing it appear in all its spectral beauty in a clear sky is a moment of still, silent magic. A full moon occurs when it is completely illuminated by reflected light from the sun, appearing as a circle of mottled brightness, sometimes silver, sometimes golden.

Each year has 12 or 13 full moons to enjoy: always 12 months with one full moon, and – normally every second or third year – one with two. The second full moon in a month is called a blue moon.

Unsurprisingly, the moon has always been held in awe. In prehistoric times, stone circles like the one at Callanish on the Isle of Lewis, Scotland, were erected to chart its course across the sky. Its correspondence with women's monthly cycles and its power to control the tides have also given it an extra supernatural boost and added to its mystery. It is something I never get tired of seeing, and something that never loses its wonder.

27 Foraging for wild garlic

The stream that runs through the bottom of my garden also runs through a nearby wood. A footpath leads from the house along the stream's banks which, during spring, are thoroughly blanketed with wild garlic. First the dark green pointed leaves appear, then clusters of white flowers, sprinkling the woodland with spots of light.

Going for a walk and returning with something good to eat (and not bought at a shop) is always a pleasure. Wild garlic is one of the easiest foods to find in the wild, one of the tastiest and certainly the most

'There is no sincerer love than the love of food.'

GEORGE BERNARD SHAW

pungent. Looking for it is entry-level foraging: it grows in abundance, especially in woodland (interesting fact: quantities of wild garlic are an indication that the woodland is old) and beside streams, and is easy to recognise. As soon as the leaves appear, we venture out with a bag and a pair of scissors, snipping off a few* to take home and make into pesto. Later on, I snip the flowers to add to salads to give them a garlicky punch and a decorative flourish.

Wild garlic (also called ramsons or bear garlic) looks a little like three-cornered leek, which I once mistakenly cooked up into a quantity of lacklustre soup, and lily-of-the-valley, which is poisonous if consumed. The sure-fire way to avoid confusion is to smell its leaves: the powerful smell can't be confused with anything else.

* As with all wild flowers and plants, it is vital to only take a small amount. Never pull up a bulb: flowers and leaves are all you need for your culinary purposes.

28 Walking barefoot

I don't know about you, but the first thing I do when I get home is take off my shoes. Nothing says time to relax like setting my feet free to wiggle and expand. It makes you wonder why we don't release our feet from their confinement and go barefoot more often; an activity that is usually restricted to a short hop between the bath and the bedroom. Which is to miss a trick. Walking without shoes and socks is a sensory, nerve-tingling experience. It's lovely indoors – on soft carpet in the winter, cool floor tiles when it's hot – but go barefoot outdoors for a truly mind-blowing, mindful experience. It can be tried on different surfaces for a variety of effects: sun-warmed sand, dew-laden grass, moss-covered rocks and even squidgy mud. The feet (and their 200,000 nerve endings) are constantly massaged as you walk. You feel in direct contact with the earth, and you begin to walk differently. Unrestrained, feet flex and respond to the territory beneath them, even if you are simply strolling across the lawn or over warm patio slabs. You begin to tread more lightly and with greater respect for your feet and for what lies beneath them.

29 Splashing in puddles

Lead a child to a puddle and they will not
cautiously step around it. No, they will go straight for it,
jumping into it, splashing and generally sploshing about.
We adults tend to bypass a puddle, wary of what lies
within it, or of messing up our shoes. Which is a shame,
as puddle splashing is guaranteed to make you feel good.
The next time it rains, I recommend putting on a pair
of wellies and going on a puddle-seeking mission. Once
you have one in your sights, don't hesitate or hold back.
Jump into it. I guarantee your world will be what poet
E. E. Cummings calls 'puddle-wonderful'.

> ‘Live in the sunshine, swim in the sea, drink the wild air.’

RALPH WALDO EMERSON

30 Letting a dog run on the beach

Nothing epitomises unbridled joy as much as a dog let off the lead and allowed to run and run. This is especially true on a wide, sandy beach when they can pound down to the sea, splash in the shallows, then power back up to you, shaking water from their fur before charging back in again. Seeing your dog enjoy this moment of unselfconscious pleasure always lifts the mood. As author Jonathan Safran Foer puts it, ‘Why does watching a dog be a dog fill one with happiness?’ I would suggest the answer is because they, more than any of us, know how to be happy.

31 The crunch of footsteps in the snow

As a child, when it snowed I was always in competition with my brother to get out into the garden first. Our intentions were different: I wanted to make the first footprints in the snow, to create a

track of boot prints across the lawn; he wanted to build a snowman and assemble an artillery of snowballs. Fortunately, when the snow was of a certain type – dry enough to settle – it suited both of our plans. What I also loved (and still do) was the sound my boots made with every step. This crunch represents snow at its best: freshly fallen, white and crisp and even. It doesn't happen immediately after snow first falls – tread on it then and you will hear something resembling a 'woof'. The snow needs a little time to settle and compress. When it has, squashing it firmly with your boots produces the familiar creak and crunch that is so satisfying and bears endless repetition.

32 Rolling up your trousers to paddle in the sea

At first it can be a little bracing, but once your toes and soles have become accustomed to the water temperature*, sea paddling is pleasure all the way. It's even better when it's a spontaneous act. You are out for a walk on the beach (perhaps with a dog, see 30) when the waves lap at your boots, beckoning you in. A need to immerse yourself becomes too strong to resist. Actual sea swimming is a step too far, but paddling is well within reason. The footwear comes off, the trousers are rolled up, your pale feet are exposed and in you go.

Gingerly at first, then with great strides as bigger waves crash towards you. The sand is soft beneath your feet, there is nothing before you except the limitless sea and the dome of sky above it. Even the water doesn't feel that cold any more. Sensory overload!

* In the UK that is, especially in the North Sea. Balmy tropical waters are another matter entirely.

33 Hoar frost on a coppice of trees

There are plenty of country walks near my house – living in the depths of rural Herefordshire ensures that – but there are one or two that are my 'default' walks. I automatically head out on these when I haven't time to plot a route or don't want to take a map. They are always familiar but never boring because they change with the seasons. One of the most thrilling times is a crisp winter morning when a particular coppice of beech trees at the edge of a wood is sprinkled with hoar frost. Bare branches, overlooked the day before, become magical and Narnia-like, coated with feathery ice crystals.

The explanation behind this fairy-tale scene is this: hoar frost occurs when water vapour in the air comes into contact with already frozen surfaces. Ice crystals form and ice continues to grow as more water vapour

freezes and attaches. On a still night, hoar frost grows well on tree branches, which remain below freezing for hours, turning them into shaggy, shimmering ice sculptures. The longer, wispier crystals are said to resemble old men's beards or hair: 'hoar' is an Old English word for showing signs of old age.

'Come forth into the light of things, let nature be your teacher.'

WILLIAM WORDSWORTH

34 The sound of the tide shifting pebbles on the beach

The sound of the sea rhythmically drawing pebbles back and forth along a beach has a deeply calming, meditative effect. Which is why many people listen to recordings of it to help them sleep. The best place to hear it, of course, is on an actual beach, sitting on the warm pebbles in the sun, looking reflectively out to sea. (Chesil Beach, an enormous shingle spit in Dorset, can't be beaten.)

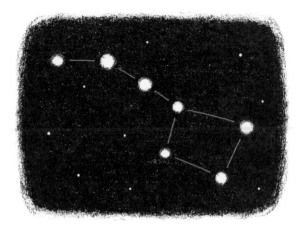

35 Identifying a constellation with the naked eye

Going outside on a cloudless night to do a spot of
stargazing is a transformative thing. By this simple act,
you step out of the everyday and off the sofa and look
upwards instead of at a computer screen or a TV. Find a
spot free of air and light pollution, let your eyes adjust,
and the experience deepens: you see constellations.
These shift in the sky depending on the season but some
are visible year-round without a telescope. The most
obvious ones are also the most familiar: there's Ursa
Major and Ursa Minor (the Great and Little Bear), and
– look over there – it's Orion's Belt! Suddenly you are
channelling your inner Brian Cox.

36 Watching a storm roll in across the sea

Seeing a storm build on the horizon, then approach towards you, is a thrilling thing, especially on a clifftop with a good view. My favourite place to do this is Gwithian Towans Beach in Cornwall, from the top of the dunes, in a café, with a pot of tea and a toasted teacake. From this vantage the whole bay, with its sweep of beach around to St Ives, can be seen easily, as can the building storm. It can be exhilarating to be standing outside with the wind whipping around your zipped-up cagoule and the rain pelting down, but personally I prefer the café-with-a-view option. A seaside hotel bar, pub or restaurant also works. Ensconced indoors, I wait and watch the show. The storm is heralded by claps of thunder then massive, surf-topped waves roll towards the shore, followed by lightning – striking the sea's surface and lighting it up with brilliant flashes – and, finally, torrential rain. It is a pleasure of the most elemental kind. Awesome. It really is.

'In nature there is nothing melancholy.'

SAMUEL TAYLOR COLERIDGE

37 Swimming in a lido

Indoor pools are all very well and have their place, but swimming goes up another level when enjoyed outdoors. When I lived in London, my favourite place to unkink the day's stress was Park Road Lido in Crouch End. It was (and still is) huge, so the perils of bumping into other swimmers were minimised, and heated, so the temperature was, after the initial body shock, perfectly OK, enjoyable even in a bracing sort of way. On a summer evening, the warmth of the sun and a gentle breeze on my skin as I swam was delicious and reviving. And on cooler days, the steam rising from the water made it feel exotic and thermal. The pool even held Full Moon Swims, for a proper connection with nature and the elements. Happily, increasing numbers of lidos are being rediscovered and restored so there are numerous options nationwide, from gentle seawater pools to hydrotherapy pools with pounding jets, to experience the thrill of open-water swimming. Park Road Lido is what I missed most about the city when I moved to the country. Similar sensations, of course, can be experienced in the 'wild' – in lakes, rivers and the sea – but without the reassuring presence of lifeguards, changing rooms and post-swim Mini Cheddars from the vending machine.

'Our lives ... are over-crowded, over-excited, over-strained ... We all want quiet. We all want beauty ... We all need space. Unless we have it, we cannot reach that sense of quiet in which whispers of better things come to us gently.'

OCTAVIA HILL

The consolations of nature

Embrace the natural world
and immerse yourself in
simple, blissful moments.

38 Planting spring bulbs

In September and October, when the garden starts to fade, planting daffodil bulbs is a symbol of hope; a belief that flowers will return. The same applies to crocus, hyacinth, allium and other bulbs; all unremarkable-looking packages that conceal the floral loveliness revealed several months hence. My favourite bulbs to plant, however, are tulips, which are best put in the ground in November. Planting anything in November is a cheering thing to do when all around you things are decaying. Clicking through a bulb company's website and choosing which varieties to grow is shopping at its best: not that costly and with plenty of choice that is full of promise. Then, with the arrival of spring, up they come, often in surprising places, enlivening borders and filling pots with colour. Which is when I congratulate myself for my horticultural skills and forward-thinking, even though it took very little effort at all. Which, of course, is part of the pleasure.

'Gardens are not made by singing "Oh, how beautiful!" and sitting in the shade.'

RUDYARD KIPLING

39 Feeding the birds

Getting to know the sparrows, goldfinches and blue tits that are regular visitors to my bird feeders is not only rewarding but morale-boosting. Helping wildlife helps us look beyond ourselves to the greater good: by providing nuts and fatballs we are assisting the natural world to thrive. Feeding the birds also provokes an intimate moment with a wild creature, which is a rare and uplifting thing. We think we're feeding the birds for their sake, but more often it's for our own benefit. Put simply, it does us good.

My own feeding station sits outside the kitchen window. It has three different feeders hanging from it: one with sunflower seeds (loved by goldfinches and

sparrows); one filled with peanuts (tits are fans of those); and one with mealworm-enriched fatballs (a big hit with starlings). I also scatter food on the lawn for the blackbirds and robins. Watching the birds and learning their habits and characters is a daily delight. I hadn't realised that starlings are so quarrelsome, for example, and goldfinches are so greedy, until they came to visit.

40 Cloud watching

The best way to enjoy a spot of cloud watching is lying on your back in a meadow on a sunny day. Seeing the clouds drift past, constantly shape-shifting, caught on thermal winds, is a blissful and meditative way to spend time. One of the great things about clouds, however, is that they are a presence above you wherever you happen to be. They can be equally satisfying glimpsed between tower blocks in the city, silently moving way up above you, a reminder that nature is doing its thing as you trudge to work.

'Nature is pleased with simplicity. And nature is no dummy.'

ISAAC NEWTON

41 Learning to identify trees

Wandering in woodlands is a wonderful thing to do at any time of the year. If, like me, you always feel better when surrounded by trees, you will know the feeling.* The crackle of twigs underfoot, the light filtered by leaves and branches, the rustle in the undergrowth, the silent, strong presence of the trees themselves, birdsong ... there are few better places to be. The experience deepens further when you get to know the trees a little better. If you learn to distinguish a hornbeam from a beech, identify a rowan by the shape of its leaves or an oak by its ridged bark, the wood, rather than being a mass of trunks and branches, comes alive, with different species jostling for your attention. There are added show-off benefits, too, of course. 'Look at that beautiful hazel,' you might say to your companion, having identified its pale-yellow catkins and jagged leaves. Or 'Isn't it great how the alder keeps its leaves so late into autumn.' Your friends and the trees will thank you for it.

* There is a word for people like us: someone with a love of forests, a 'haunter of woods', is called a nemophilist.

42 Seeds germinating on a windowsill

There were several months in my new house when I was without a greenhouse. I had a small one in the previous garden and had grown to depend on it – it was the engine room of the veg patch; the place to germinate seedlings, grow tomatoes and over-winter the more delicate plants. Fortunately, the new house has several windows with generously sized windowsills. As soon as March arrived, I was sowing seeds into trays of compost, covering them with odd bits of glass found in the garage, and waiting. Every day, on seed patrol, I peeped under the glass, looking for signs of growth. Eventually, there they were: rows of green spikes pushing their way upwards. Seeing a tiny brown chip turn into a green plant always feels like magic to me, especially when it goes on to grow into, say, a cabbage. From a seemingly desiccated scrap, an entire plant grows. The power and potential of seeds: what a truly great and rewarding thing that is. Since the new greenhouse arrived, my seed growing has reached an industrial scale. It's hard to resist the promise of a seed packet and I see no reason to.

43 The hoot of an owl

Few things are guaranteed to raise the hairs on my arms as much as the low-pitched hoot of an owl, rolling out from the wood and across the garden at dusk. Haunting and melancholy, the *hoo hoo hoooo* is the territorial call of the tawny owl* and can be heard from late autumn through to winter. Sometimes it is possible to eavesdrop on an owl conversation: the deep hoot of a male can generate a *kewick* response from the female. Owls are nocturnal creatures, making the night-time calls even more eerie – like the call of a disembodied spirit or a witch on her way to a sabbat. Magical.

* Not all owls hoot. Some owls screech, others bark, growl, shriek or chirp, it depends on the species and what they are communicating.

44 The sound and movement of wind in the trees

Those nemophilists (see 41) among us know that a walk among trees is never silent. There is a constant, soothing soundtrack caused by the wind moving through the branches and leaves. The timbre of this varies in pitch and volume, depending on the force of the wind and the size of the eddies it produces as it passes through the trees. On a summer day a friendly rustle, or susurration, may ripple through the branches; on a blustery one, a more high-pitched whistle building to a roar. Whether the wind passes through a copse of trees, a forest or a single tree in the garden, this music of the woods gladdens the heart. It's like the voice of nature whispering into your ear, reminding you of its wild and unruly presence.

45 Picking blackberries, then making a pie

For much of the year, brambles are a nuisance. They thread and tangle their way through the hedge at the bottom of our garden, choking the hawthorn and beech, inflicting deep scratches when an attempt is made to remove them. Come late September, however, it's another matter: they are beaded with small, sweet, delicious blackberries. A blackberry bush is a tough and resilient thing, growing on wasteland, in parks,

alongside railway tracks. It provides the rambler and urban walker with a fruity pit stop; an opportunity to pause, harvest (or 'bramble') and snack along the way. Many a pocket has been stained with its purple juices; many a mouth refreshed with its tempting berries. Best of all, many a pie has been made from its fruit (often accompanied by freshly cropped apples) and served with custard or a big fat dollop of double cream.

46 Bats flying overhead at dusk

When I lived in North London, I would boast about the birds that flew overhead at dusk, diving and flitting through the trees in Alexandra Park. A friend gently pointed out that these weren't birds at all but bats. This was an exciting piece of news: I had no idea that bats existed in cities. Once identified, I kept a constant look out for them. As everyone knows, bats are creatures of the night, furled up in their wings during the day, and emerging in the evening to feed. Sunset is the best time to spot them: for a couple of hours they leave their roost and nip about, hunting insects and looking for water. Hearing the sound of their wings and feeling the rush of their movement through the air above my head was, and is, a total thrill.

47 A drift of snowdrops

Just when winter has gone on for far too long and the days are still too short, up they come. Little clusters of joyful white blooms, breaking through the earth and snow. When little else is in flower, their hanging, bell-shaped flowers rise pluckily from the frozen ground like a miracle.

48 Lambs jumping and playing

You are driving (or walking) along a country road one spring morning and suddenly you see them: newborn lambs. There they go, running about in gangs like exuberant toddlers, every so often jumping into the air just for the fun of it. A burst of joy rises up in your chest. No one knows how to kick up their heels like a playful, spirited young sheep.

'Nature never did betray the heart that loved her.'

WILLIAM WORDSWORTH

49 Growing your own food

The first vegetable you grow (often a radish) is a wonderful thing. The pride that comes from cultivating a seed, seeing it grow into an actual vegetable, is enough to swell the head and put a strut in your step. Plus, you get to eat it! The rewards of growing your own food are immense, as increasing numbers of allotment holders and back-garden veg growers appreciate. Since moving to a smallholding in the country, I am lucky to have a polytunnel and a greenhouse, and use both to populate the veg patch with a variety of leafy greens and roots. This is a dream I harboured for years when I was living in the city. There, the only place to grow food was my tiny back

garden and a small raised bed in the community garden. Now I have space to grow an abundance of potatoes, leeks, cabbages, tomatoes, beans and – bliss – raspberries. Pulling potatoes is among my top things to do (almost up there with spending an afternoon in the greenhouse pricking out and potting on while listening to the radio): seeing them emerge from the earth is little short of a miracle. Cooking them straight from the ground and dishing them up to family and friends makes any labour involved in their production worthwhile. Even the labour is mostly pleasurable, come to think of it. Growing your own food really is a win-win-win.

'If you look deep enough you will see music; the heart of nature being everywhere music.'

THOMAS CARLYLE

50 Getting up early to listen to the dawn chorus

It's always quite difficult to get up early, I find, but it's easier in summer, especially when there is a good reason. Listening to the dawn chorus is reason enough for me. This uplifting performance, when massed birds break into song, takes place right outside the back door, so I don't have to move very far or even take off my pyjamas. All I have to do is pull back the curtains just before the sun comes up (around 4am in early summer), open a window and listen as the air is filled with joyful birdsong. Do this on International Dawn Chorus Day, in May every year, and you join a worldwide celebration of this heart-warming noise.

51 An orchard full of blossom

May is one of the best months of the year. Dangers of frost have largely passed, and plants have got into their stride, with gardens filling with foliage and flowers. Central to the loveliness of the month is blossom, particularly apple blossom, and especially apple blossom in an orchard. Orchards are nature at its most abundant and beautiful. Another reason I moved into my current house is because it had one: I had always dreamed of swinging in a hammock on a sunny day between two blossoming apple trees. That hasn't

happened yet, but the option is always there ...
Meanwhile there is the gorgeous April through to
May display to enjoy: clouds of pink and white apple
blossom buzzing with pollinators and the promise of
the harvest (and juice) to come in October.

52 The squawk of a herring gull

Anyone who has spent any time by the British
coast can identify the call of the herring gull, the
biggest and baddest of all the gulls*. Easily identified
by its large size, pink legs and the red dot on its yellow
beak, its call is the sound of the seaside and should be
treasured as such. Its squawk is a difficult sound to
describe. It varies from plaintive to yelping to shrill,
depending on whether it is an alarm or a mating call,
but hearing it – no matter where you are – immediately
triggers memories of ice cream, fish and chip suppers,
and sand in your sandals.

Demonised unfairly for chip-stealing (they are
simply looking for their next meal – not a crime in
my book), herring gulls are actually intelligent and
resourceful creatures. Their numbers in coastal areas,
however, are dropping as fish stocks diminish. My most
memorable encounters with them are the noisy bunch
who woke me in my B&B from their rooftop nests
in Penzance, and the handsome fellows perched on

bollards near the fishing huts in Hastings. It would be a terrible shame if these experiences decrease.

Many gulls, especially the great black-backed gull, have moved inland in search of food and can be seen circling above feeding grounds such as landfill sites. Even in these bleak and filthy places, their cries are transporting and evocative.

* The word 'seagull' is too vague and inaccurate to describe gulls: there are around 50 birds of the genus *Larus* (gull), and none are known by the name 'seagull'.

53 A bird of prey wheeling in the sky

There was a time when, propelled by romance, I motored up and down the M40 most weekends. As the car approached Oxford, the sky increasingly became filled with red kites, circling slowly above the road on the look out for their next roadkill meal. Every so often, when there was a gap in the traffic, they would sweep down to the road to feed. It was (and is) an exhilarating sight, and happily one that is more common since the birds were successfully reintroduced into the Chilterns in the 1990s.

Birds of prey inspire awe like no other. Built to hunt with laser-like vision, incredible turns of speed

and hooked beaks and sharp talons to rip their prey apart, they are the daddies of the sky. Seeing one is like getting a jolt of the wild: thrilling and dangerous in equal measure.

54 Watching swans and their cygnets on the canal

The canal near my old house in London was a precious resource: a ribbon of nature running through an urban development. On one side was the railway track into the City and, on the other, several blocks of imposing modern flats. Walking alongside the canal on the way to work, I would look out for any waterfowl who had settled there. It was my little dose of nature before descending into the Underground and on to a day in front of a screen in an office. I grew especially fond of the comical coots with their clown-like striped feet and portly bodies who settled on sewage pipes in nests made resourcefully from grass and plastic rubbish. But it was the swans who were the stars of the show. In spring, the cygnets would appear on the canal, usually six dizzying bundles of fluff who zipped around on the water in the wake of their parents. Every day I would anxiously count them, terrified that one might have perished. The relief that they were all present was followed by sheer delight: watching them grow, shed their grey Ugly

Duckling fluff (which is not at all ugly, of course) then disappear as they, ahem, swanned off to start a family of their own.

The company of others

Hanging out with compatible people is the best endorphin boost.

55 Unexpected cake

Cake is pretty wonderful at the best of times but when it arrives unannounced, there is little better. Being presented with two layers of Victoria sponge filled with jam and dusted with icing sugar (other cakes are available) that someone has taken the trouble to bake is truly touching. That person cares enough about you to shop for the ingredients, spend their time greasing pans, measuring ingredients, mixing and beating, and anxiously peering through the oven door, before decorating it and, finally, presenting it to you. Birthdays are the obvious time to receive such a cake, but other, more random, times are even better. A cake as a thank you gift perhaps, or to congratulate some triumph, or for when you move into a new house (thank you Catherine for my delicious Dundee cake which kept us and the removal men going), or simply for no reason at all.

56 Being cooked for

Hearing the clatter of pans and the chopping of vegetables in the kitchen as I loaf about on the sofa in the living room with the TV remote and a magazine is one of my favourite pastimes. My other half has a clever way with spices so these promising sounds of a meal being cooked are frequently followed by the

tempting smell of onions and garlic browning, and coriander and cumin being cooked off. Anticipation is half of the pleasure of any meal, and when it is not you in the kitchen preparing it, the pleasure grows further. Arriving at someone else's house for Sunday lunch and being greeted by the taste-bud-tingling smell of a roast in the oven also takes some beating. All that is necessary is to sit down, savour every mouthful and voice your appreciation (oh, and help with the clearing up).

57 A long chat with a friend

Handy though WhatsApp and text messages are for keeping in touch with friends, sometimes a string of emojis accompanied by a humorous GIF just doesn't cut it. What is needed is some actual face time with a real person, preferably in comfy chairs in a convivial pub with a bottle of wine on the table. A long phone conversation at home with similar accessories (i.e. chair, wine) also works. Having the time to talk to someone whose company you enjoy, and allowing the conversation to drift off in different directions, is one of life's greatest and most rewarding luxuries.

58 Being brought tea in bed

A mug of tea on the bedside table, brewed by another, is worth waking up for. Not only does it make you feel waited upon and therefore cared for and a little bit grand ('Just put it on the bedside table. Thank you.'), but it enables you to lie in bed among the soft pillows and warm duvet for just a little while longer. Dreamy.

59 Holding hands in public

There are two versions of this public display of affection. The first is the adorable moment when children hold each other's hands or reach for an adult's. And the second is a romantic moment between two adults. This tends to peak in the early part of a relationship, then peters off during the middle years when it can cause children embarrassment (but what do they know?), only to be revived in later life when you realise the spark is still there. Seeing two elderly people holding hands as they potter down the high street is a life-affirming moment. How lovely that they still care about each other after all this time.

60 Planning a walk with a map

For me, part of the pleasure of a walk is poring over a map and plotting the route. Tracing footpaths and bridleways with a finger, ringing ancient sites with a pencil while avoiding steep contours, is a particularly pleasing process. It is the start of understanding the landscape that we shall soon be walking through. It sees me excitedly tapping the map and pointing out a patch of ancient woodland, a well, a quarry with a lake, a pub. The map is then safely stored in a pocket to refer to as we set out. The landmarks and features spring to life, some more impressive than

anticipated, some less. And when we drift off the route (i.e. get lost), the map is on hand (no signal necessary: take that, GPS!) to put us back on the right path.

61 Old family photographs

My father was a keen amateur photographer and captured many special occasions on film. These images existed as transparencies and every so often he would arrange a screening to show them via a rickety projector on a screen rigged up in the living room. After his death, they lay forgotten in dusty metal boxes until my brother rediscovered them and had them digitally converted. Various members of the family from different generations gathered for a viewing. It was wonderful to see my dad as a young man at the helm of a motorboat, my mother by the Niagara Falls (they had emigrated to Canada), and our birthday parties over various years with various cakes. The younger family members also enjoyed seeing we elders as children in fancy dress (or so they said), or running naked towards the paddling pool.

Every home once had boxes of old family photographs, with the names of those pictured and their whereabouts scribbled in pencil on the back. 'Aunty Min, Bridlington, 1954.' The more orderly would fix them in albums and date and annotate them, sometimes with 'amusing' captions. It is ironic that although now we take more

images than ever on our phones there is a danger of few being available to future generations, as they are abandoned on the cloud or a hard drive. It is worth remembering to print a few to save them as tangible things. Then they can lie in a dusty box in a cupboard until they too are discovered, shared and delighted in.

62 Regional dialects

My other half prides himself on being able to identify anyone's accent. 'You're from Darlington, right?' he will say definitively, or 'You grew up in South Devon, didn't you?' – and he is usually right. He has an ear for the subtleties of regional dialects. The UK's varying dialects are something to be proud of and celebrated, indicating as they do the differences in culture, character and attitudes across the land. Arriving in another part of the country and immediately hearing a different-sounding voice is also an indicator that you have travelled somewhere else. Similarly, hearing, say, a Yorkshire accent, when you live in Wales is intriguing and interesting. How dull it would be if we all spoke with the same intonation.

63 Playing board games into the night

In my experience, this most often applies to Monopoly, a game that can stretch into infinity. Scrabble can also warp time. One player always wants just one more game to even up the score. Which is totally fine, excellent even, as both are totally compulsive. Accompanied by snacks and beers, playing board games with friends and family is a most agreeable and companionable way to extend the day. (A jigsaw puzzle can also lock you into its sweet yet interminable embrace as you look for just another piece and another into the wee hours.)

'We don't stop playing because
we grow old; we grow old
because we stop playing.'

GEORGE BERNARD SHAW

64 The words 'I've put a hot-water bottle in your bed'

These were uttered to me by a friend I was staying
with one weekend and are among the most comforting
I have ever heard. I thought about that little pocket of
warmth and kindness waiting for me as we ate our meal.
It was anticipation of the most cosseting kind.

65 Helping a stranger

It's tricky to acknowledge that an act of
kindness towards others can be a pleasure. It feels as
though it should be carried out without a whiff of
self-interest, purely for the good of the other person.
The feeling of well-being or mild euphoria that arises
post-charitable act – there is even a term for it, 'helper's
high' – however, isn't a bad thing and shouldn't make us
feel guilty. Better to think of it as a reason to do more

good things. (Within reason, of course; unsolicited help is only helpful when it is genuinely needed, not foisted upon a defenceless stranger.) Swinging into action and helping someone in trouble not only benefits that person but is personally satisfying and rewarding. You walk away a little taller, feeling connected with your fellow man and the community, and proud that today, at least, you have done a Good Thing.

66 Inherited family things

On a shelf above the desk where I work (and where I am writing this) is a little brass pig with a curly tail and a snub nose. It is about 5cm long and if you pull its head, a lipstick holder is revealed, which still has traces of cerise lipstick around its rim. This little pig belonged to my grandmother and I think of her whenever I look at it. Every so often I give it a polish with a rag and some Brasso. I've had it since I was a child, when I pretended that I was going to a party and put it in my 'handbag' to take with me. I never saw my grandmother use it, but I like to think that she really did take it to a party, tucking the little pig into a smart evening bag as she and my grandfather went out to a work dinner dance. Little mementoes like my brass pig (not flashy heirlooms that have travelled through several generations) are a hotline to those no longer with us,

often triggering a wave of warm memories. The fact that they have little use or value to other people makes them more treasured, not less.

67 Making a baby laugh

Babies can be inscrutable, staring wide-eyed and unblinking as you, the responsible adult, pull a face, tickle their toes or jiggle a brightly coloured toy in front of them, willing them to laugh. But when you get it right and the baby chuckles, it's like the sun coming out from behind a cloud – a big yellow Teletubby sun beaming happiness. Which is why trying to make one chuckle is worth persevering with, even when it looks like the tears and scowls will never end.

'On that best portion of
a good man's life,
His little, nameless,
unremembered acts
of kindness and of love.'

WILLIAM WORDSWORTH

68 Sitting around a bonfire

There's something about a fire that makes you want to draw near, to gather. It inspires the sharing of confidences and the telling of stories. Instead of the often-silencing presence of the TV, a fire is a sociable thing, a living, warm focus, not a flat screen. Light one outside your tent when camping, and your holiday becomes that little bit more adventurous. Other people, strangers, may join you, warming their outstretched hands.

A couple of my friends are bonfire makers par excellence, and often light one in their smallish back garden. In winter, we wrap up in big coats and huddle around it with mugs of soup; in summer, it is a place to keep warm and toast marshmallows, as the sun sets and the air gets chilly. Keeping it alive is part of the pleasure: logs and branches are thrown on, sparks fly up, and the next day everyone's clothes smell of smoke. It brings a little bit of the wild into our lives for an hour or so before we return to the comfort of the indoors.

'Time you enjoyed wasting, was not time wasted.'

JOHN LENNON

69 Blowing bubbles

Creating a translucent, shimmering orb and then sending it floating off into the air is the simplest of magic tricks. The wonder of turning an unremarkable bowl of soapy* water into a fragile sphere increases when bubbles are blown for a child and amazement is reflected in their awestruck face. Passing the bubble wand to them to blow some themselves is like handing them the gift of sorcery.

* Handy tip: add a teaspoon of glycerine to one part washing-up liquid and one part water to make bubbles last longer and float further.

70 Seeing your long shadow alongside your friends'

This always reminds me of late summer evenings after a long walk, when the sun is low and shadows are at their lengthiest. It marks the end of a day happily spent walking, talking and discovering a new part of the country with some of my favourite people. Now we are on our way home and our shadows are stretched out in front of us, side by side, like we are big friendly giants striding home for tea.

'One doesn't recognise the really important moments in one's life until it's too late.'

AGATHA CHRISTIE

71 Getting the giggles

There's nothing like sharing a good old belly laugh with another person. The sort of laughter that builds uncontrollably until you are both helpless with it. I frequently got these attacks of the giggles as a child with my first best friend, most often at times when it was frowned upon, like during school assembly or at a carol service. Adult giggles are less frequent but more enjoyable because of their rarity. They are also far more likely to occur with someone else, making them the best bonding exercise there is: laughing heartily with another indicates that you like this person and agree with them. Plus, science tells us, this sort of helpless laughter lowers the heart rate and blood pressure. Mostly, though, getting the giggles is simply the best fun.

The solace of solitude

Learn to treasure those quiet, solitary moments and the untrammelled pleasures they bring.

72 Taking a random day off to do nothing much

While it's great to get things done (see 79) it feels good, every so often, to be free from the tyranny of the to-do list. It's liberating to book a day off, then do nothing but loaf. This works best done alone, as other people tend to make demands, or at least force you to have a conversation. The perfect slouchy day for me starts with a lie-in, i.e. waking up without an alarm trilling in my ear, followed by a big, carb-laden breakfast. The rest of the day is spent mostly on the sofa, reading, listening to the radio, rediscovering favourite music, watching a film, or staring vaguely into space, letting thoughts rise in my head. The only interruptions to this leisurely and agreeable state of being is when I nod off or wander into the kitchen for snacks. Bliss.

73 Dancing in the kitchen

There you are, loading the dishwasher or pulling endless odd socks out of the washing machine when you hear it. A song that you haven't heard for ages. A song that you love. No one is around. The familiar tune works its magic. You stop what you are doing and start to move. Soon you are dancing, a little bit foolishly to start with, then, in a spirit of who-cares-anyway, even more foolishly. You wonder why you don't do this all the time.

74 Opening a new notebook, packed with possibilities

One of the few pieces of advice I have taken from a relative was from my elderly aunt. 'Don't buy things and put them in drawers,' she said, referring to a cupboard full of bedlinen she had never used. The same can be said of notebooks. Some are too nice to use: beautifully bound, with endless pristine white pages and a ribbon bookmark. I had a shelf full of such notebooks, some waiting for a great idea, others with a few pages of scrawled writing that didn't match the handsomeness of the book. Eventually I realised that avoiding using a new notebook out of fear of spoiling it is to deny it its purpose and me my anticipatory pleasure. A fresh notebook is packed with possibilities. It is a place to

capture thoughts, dreams, ideas. It's somewhere to scribble, doodle, work things out. And when it is full, it is a record of all that thinking, planning and, hopefully, subsequent action. If you have a lovely one waiting to be used, get it off the shelf, open it, stroke the first page and fill it up. Leaving it empty is boring – and notebooks should be anything but that.

75 Having an afternoon nap

Having been brought up in a household where any sort of inactivity during the daytime was discouraged, it feels deliciously illicit to have a lie down in the afternoon. Particularly during the week when work is normally going on. I realise this makes me sound like a slouch, but I do love a nap as the rest of the world goes about its business. An afternoon snooze is easier to accomplish if you work from home, or are retired, and consequently the master of your own time. (Offices really should have sleep pods to encourage employees to take a reviving kip.) Between 1pm and 3pm, many of us are overcome by an energy slump with alertness dimming as eyelids lower. Rather than battle against this natural dip, how much more rewarding it is to succumb to it and have a little lie down. A time limit is necessary to avoid wasting the entire day and ruining your night-time sleep. Restrict napping to 10 minutes or half an hour

'An extra yawn one morning in the springtime, an extra snooze one night in the autumn is all that we ask in return for dazzling gifts.'

WINSTON CHURCHILL

(personally, I favour half an hour), then you won't enter deep sleep and feel even more sluggish when you wake up. I find that covering myself with a blanket and taking a short nap on the sofa feels less indolent, almost accidental, than actually going back to bed. Post-nap, after a few moments of initial drowsiness, I am quite perked up, batteries recharged. Apparently, daytime snoozing also improves short-term memory and cognitive functions, so there is absolutely no reason to feel guilty about it. Think of it as a necessary pleasure.

> '**This is what I hear all day – the trees are singing my music – or have I sung theirs?**'

EDWARD ELGAR

76 Daydreaming

Letting the mind wander is a creative exercise. A thought occurs, maybe a creative idea or a plan, or a potential romantic attachment. This could crop up as you walk to the shops or stare vacantly out of a train window. You run with it, galloping mentally into the future, imagining outcomes and a new way of living. For a while you inhabit this world with all its rosy promise. A jolt brings you back, but the effect lingers. It could even be the start of something really great.

77 Eating leftovers for lunch

This works best with a takeaway curry, I find. Friday nights often see us calling our local curry house and putting in a delivery order for chicken

jalfrezi and tarka dhal, keema naan (him), veggie
thali and mutter paneer (me). Food enough for twice
the number of people, in other words – the problem
when you order post-work and think that no amount
of dishes will satisfy your hunger. This means there is
always a generous quantity left over. As a result, come
lunchtime on Saturday there is an exciting moment
when I realise that there is a delicious meal waiting in
the fridge. All that is needed is a quick blast in
the microwave to deliver a plate of something hot and
tasty. And it *always* tastes better the next day.

78 Reading a magazine from cover to cover

Magazines are often seen as a bit of a treat; something
unnecessary, a bit of an extravagance. As fewer people
now buy them and they have become more expensive,
this is increasingly the case. Which makes savouring them
all the more pleasurable. Settling down with a favourite
title and plenty of time is an engrossing luxury. Rather
than briefly scanning it, then putting it with the others
in a pile to read later, knowing you probably won't, you
can settle down and read it page by page, poring over
every last word.

79 Getting things done

Although there is a danger of being a slave to the to-do list (see 72), it is really satisfying to get something done. Especially if that thing has been hanging around on the fringes of your consciousness for months, niggling away, irritatingly. For me, this state of affairs is epitomised by my automatic cat flap which, for ages, confounded me. This was caused by not reading the manual and 'applying myself', as my old headmaster would put it. As a result, the local Bad Cat would stroll in, eat my cats' food, snarl menacingly at them, then hop back out, leaving my two in a state of nervous anxiety. So, the day I took the manual out of the drawer, read it, followed the instructions and actually installed the thing, restoring equanimity to the household, was a good one. Not only did it fill me with a sense of pride and accomplishment, but it meant that my cats could eat their bowls of crunchy goodness in peace once more. And there was one more item ticked off the to-do list.

80 Placing the last piece in a jigsaw puzzle

Jigsaw puzzles are a satisfying pastime. They soothe and occupy the mind, offering a distraction from whatever else is going on. Recreating an image by locating and placing odd-shaped pieces restores order,

even if all around us is chaos. This urge to finish a jigsaw can drive a person on without a break, sometimes compulsively searching for the right-shaped piece of sky until the early hours. And the best bit is placing the final piece and completing the picture – a satisfying moment of air-punching achievement that can elicit a whoop of pride.

81 Climbing a hill

Whenever I'm out for a walk and a hill comes into view, I groan. My first thought is how to avoid it. Is there a path that circumnavigates it?* Generally there isn't and there is nowhere to go but up. So up I go, puffing and panting, stopping frequently to 'admire the view', wondering why I do this to myself. But once the summit is reached, all the pain is forgotten. Now I am higher than everything else. Views stretch out in 360 degrees. A breeze refreshes my sweaty brow. It is a moment of accomplishment rewarded with beauty. Totally worth it.

* Actually, there is much to be said for circumnavigating a hill. The summit of Mount Kailash in Tibet has never been climbed as it is regarded as a holy place. Instead, pilgrims walk reverently around its base, a circumambulation known as *kora*.

82 Lying under a tree

The perfect place to lie and daydream is beneath the boughs of an ancient oak. This is best during summer when its canopy of leaves casts a dappled shade and offers protection from the heat of the sun. Looking up past its gnarly trunk into the interlacing branches, you can sense the tree's sturdy roots plugged into the earth beneath you. I imagine I am absorbing the oak's wisdom and strength as I rest there. It is as peaceful a place as you can find.

83 Taking your boots off after a long walk

My neighbourhood is laced with public footpaths that take me through woods, along brooks and up hills. Every day I itch to put on my walking boots and set off along another one. Life frequently gets in the way, but when it doesn't I walk a goodish distance. The walking is an uplifting thing to do but so is coming home, especially unlacing those boots and letting my feet free again after hours of restriction. Now the toes can wiggle, the foot can flex and any blisters can be inspected before I dip both feet in a cool bath. Just lovely.

84 Not moving because a cat is asleep on your lap

There is much to be said for the notion that our purpose on this earth is to serve as cat butlers. Of all creatures, they make their desires plainly and emphatically known, communicating surprisingly effectively through a variety of mews and slinky moves. My oldest cat is especially vocal and demanding, and will not be quiet until she has been fed/brushed/let out/generally attended to. The one time I actually appreciate this is when she lands on my lap as I'm watching TV. Once

settled, which can take a while, nothing will move her, and I wouldn't dare try. Mostly because it is to my benefit: having her sleeping heavily on my lap enforces my immobility. It is a justified excuse to do nothing for an hour or so. Disturbing her is simply out of the question.

85 Wearing a favourite jumper

I am wearing my favourite jumper as I write this. It is old, baggy, navy blue and has a crew neck. At one time it was fashionable – it has knitted frills on the sleeves – but now it is shapeless and out of date. There is a hole in one sleeve and tufty strands of wool sticking up all over it, extracted by an over-enthusiastic cat. Nevertheless, I love it and turn to it whenever I need a bit of wraparound comfort. It is also roomy enough to sling on over anything and conceal whatever lies beneath. A great big hug of a jumper.

'I felt so intensely the delights
of shutting oneself up in a
little world of one's own, with
pictures and music and
everything beautiful.'

VIRGINIA WOOLF

86 Rereading a loved book

While it is exciting to discover a new author, sometimes nothing beats returning to an old favourite. It is comforting to revisit a book discovered years ago, to meet the same characters and to retrace their story. Repeated reading isn't just about the old and familiar, however. It can throw up new things: details previously skipped over come to light, plot twists are finally understood, the writing sparkles afresh. A deeper understanding is forged.

My go-to writer when I need to read something familiar and uplifting is the American author Lorrie Moore and my favourite book of hers is *Anagrams*. Its

five linked short stories have been with me since my twenties when I was dazzled by their wit and cleverness. Reading it again and again over the years, I have come to appreciate other qualities that I had previously missed. It is actually a book about love, death and identity. All the big topics, then, wrapped in a blanket of humour. And one that certainly merits rereading.

87 Turning off the alarm and sleeping in

There are few days when I welcome the sound of the alarm. None, actually. It is always intrusive, jangling or peeping in my ear, insistently demanding that I get up and get on. It tries to fool you with its appealing 'snooze' button but that is a trick. In a matter of minutes any snoozing will be rudely interrupted once more. So those days when I don't have to dance to its tune are pure joy. Instead of groaning at the persistent racket, I can reach over, press 'stop' and drift blissfully back to sleep.

88 Dozing in the sun

This is best achieved accidentally. It is a summer afternoon. You are sitting on the grass on a deckchair with a book, intending to catch up with your reading, when a drowsiness descends. The warmth of the sun envelops you. It is impossible to resist. Soon you are slumbering sweetly without a care in the world.

'Summer afternoon – summer afternoon; to me those have always been the two most beautiful words in the English language.'

HENRY JAMES

The joy of creativity

Learning and making things can be tricky and time-absorbing but the rewards are bountiful.

89 Whistling

Where have all the whistlers gone? The postman announcing his arrival with a discordant whistled version of a pop song as he strolls up the drive? The doorman outside a hotel whistling up a cab? Once, whistling was so common that signs were put up to stop its practice. Which was a tragedy: whistling is a sound guaranteed to cheer up both the whistler and those who hear it. It symbolises cheerfulness and nonchalance. It is to be treasured. Having said that, I have never been that great at it, but I do admire those who are. My grandfather was a dab hand, summoning dogs by putting two fingers in his mouth to produce a piercing whistle, and jauntily whistling tunes from Gilbert and Sullivan as he pottered about in the garden. He attempted to teach me many times, but I never quite got it, more often emitting a raspberry or a soundless, whispery breath. Knowing that it is a skill worth acquiring, however, I have been practising. And in the process, I have learned that it's all about the shape of the lips (they should be puckered), the position of the tongue (along the bottom of the mouth with the tip curled against the teeth) and the amount of air that is blown (a gentle stream). It also helps to pick a catchy tune with a strong melody. Once I have mastered it, I shall be sauntering into town, hands in pockets whistling 'Colonel Bogey', or similar, and dispensing good humour as I go.

> ‘Life isn’t about finding
> yourself. Life is about
> creating yourself.’

GEORGE BERNARD SHAW

90 Writing a letter

Rather than tapping texts and messages on a phone or rattling out an email on a keyboard, it feels good sometimes to take a piece of paper, find a pen and actually write a letter. You will also rediscover your handwriting (even if it is appalling, it is still your own). The process of letter writing is a slow one, making you stop and think what you want to say before committing it to ink. Once it is written, there is no delete button. Then there is the business of finding a stamp and a postbox to send it on its way. On arrival at its destination all of this will be worth it as you will not only surprise and hopefully delight the recipient, but they will appreciate the time and thought involved. This all ramps up to another level if you are writing a love letter, of course, because the chances are that it will be tucked away safely and kept for a good long time.

91 Baking bread, then eating a warm slice

Put a loaf in the oven and soon a trail of hungry people will emerge in the kitchen, sniffing the air, stomachs rumbling. Few smells are as irresistible as bread baking, and few things are as thoroughly delicious as a slice fresh out of the oven and slathered with butter. The business of bread-making is the epitome of homemaking, comfort and domesticity. Of course, all that kneading and proving takes time and requires patience and motivation*, but a slice of warm bread eaten as the butter drips over your fingers is reason enough to do it.

* Confession: I have a bread maker. All you do is pile the ingredients in and switch it on. It's a game changer. And it smells just as good.

92 Discovering a new piece of music

There you are, noodling about on YouTube or Spotify, following recommendations, going down wormholes, when you unexpectedly hit on something magnificent. A piece of music that makes you sit up and really listen. One that triggers a rush of excitement; one that you immediately want to share with all your friends. A tune that will soon become a new favourite that you can't resist playing over and over, even though you know you are in danger of listening to it too much and getting bored with it. For a moment, you are back listening to the radio as a teenager, being thrilled by a new record played by a favourite DJ. You are transported. Music has the power to do this.

93 Learning to play a tune

Anyone can pick up an instrument and make a noise but, really, what is the point of that? You might as well just hit a saucepan and holler. No, the real joy comes from turning the racket into a melody. This takes practice, of course, and some painful moments during the learning process, but the moment when the faltering notes and rackety sounds become a recognisable tune makes all the pain worthwhile. While this is a pleasing achievement in itself, it becomes even

more so when the tune is performed to others. Learn a few tunes on a piano and you will have a repertoire. Then you can encourage others to sing along, and little is as old-fashioned and cheerful as that.

94 Choosing a font

These days, thanks to digital technology, we all have a favourite font. (Mine is Calibri, if you're asking.) Once the preserve of graphic designers and typographers who revelled in chat about serifs, kerning, the beauty of Helvetica and the horrors of Comic Sans, now fonts are freely available to all. And what a choice there is: click on the drop-down menu and you will find one for every purpose, mood and personality, and new ones are constantly being added. Many are named after the typographer who designed them and come with their own design history. Finding the font that suits you or your purpose is like making a new friend – reassuring and packed with promise.

'There is something delicious about writing the first words of a story. You never quite know where they'll take you.'

BEATRIX POTTER

95 Writing a short story

Creative writing is close to my heart as I am always in the process of finishing a novel. As that never happens, I have turned to writing short stories. Foolishly, I thought they would be easier to write but they are not. Any flaws or inconsistencies shine from the page like a beacon. Like any creative endeavour, however, writing a short story (and actually finishing one) is a rewarding thing. The best part is the start, when you commit your idea to paper and make it real. You have created a world, invented characters, made them do things, given them an inciting incident and set them off on a hero's journey. It's no mean feat and a truly satisfying one.

96 Doodling

My first boss doodled throughout every meeting. Her doodles were mostly of spiny creatures that resembled spider crabs, although sometimes she gave them extra legs and they would scuttle about her jotter. It gave her a thoughtful, slightly distracted air, as though she was engaged in what was being said, but not that much. I'm not sure if this worked to her advantage in meetings with the bigwigs, although it made me appreciate her more. My doodles were, and still are, shapeless, amoeba-like squiggles that wouldn't do anything as adventurous as scuttle. I do love to doodle, though, most often when I'm on the phone. It's a form of daydreaming, where instead of letting the mind wander you let the pen go free. There's no telling where the line will lead. Soon an envelope is covered with an elaborate ink scrawl that vaguely looks like a flock of birds, or the edges of a document resemble a badly drawn medieval manuscript. Most doodles serve their purpose – which is often to relax and de-stress so shouldn't be belittled – and are then discarded. But that's OK, ephemerality is part of their charm. They represent a moment of thought captured in abstract form. Beautiful, really.

97 Wrapping a present

It took me a while to learn to love wrapping presents. My first, admittedly childhood, attempts were bungled affairs involving crumpled, finger-marked paper, twisted Sellotape and mismatched labels. But then someone, probably my present-wrapping-ninja mother, taught me to tuck the edges of the paper diagonally, and I was away. Since then, I have loved to wrap, especially if the gift inside is a good one, i.e. something the giftee will (hopefully) love. Choosing paper, label, ribbon, then assembling them in a pleasingly coordinated manner, is a chance to think about that person and to anticipate their response as they unwrap it all later. It is a creative act with heart.

98 Singing loudly in the car

There are few places where you can really open your lungs and bellow a tune without risk of sneering condemnation from family members. Driving solo in a car is one.* For me, the prospect of a long drive is much improved by the anticipation of listening to some favourite tunes and singing along. In weaker moments, I turn to radio stations playing 'classic pop' because they are so familiar that I usually know the words. For full vocal pleasure, however, I play personal favourites. Most are too embarrassing to list here but I do have a liking for a classic road-trip playlist that includes the likes of 'Radar Love' by Golden Earring, 'On the Road Again' by Willie Nelson, 'Going Up the Country' by Canned Heat or 'Born to Run' by Bruce Springsteen (I could go on). These make the journey seem epic, as though I'm powering along the Pacific Coast Highway in California, not the A4103 to Hereford. When the familiar music begins, I'm off, belting out the lyrics, safe in the knowledge that no one can hear me, and the only attention will come from motorists at traffic lights puzzled by my exaggerated mouth movements.

* The shower is another, but lack of soundproofing in mine inhibits the singing of power ballads at full volume.

'I am always ready to learn although I do not always like to be taught.'

WINSTON CHURCHILL

99 Learning to knit, paint, draw, throw pots ...

My father was a principal of an adult education centre and I was brought up with the strong belief that you should never stop learning. The college he ran specialised in art classes with rooms full of classical statue plaster casts and walls lined with the – to my teenage eyes – racy output of the life-drawing class. It thrummed with creativity, excitement and pride, and was the bohemian heart of the town. It instilled in me the joy of learning and of making, and I have been a non-stop attendee of evening classes ever since. It's the mix of achievement, chummy sociability and self-improvement that is so addictive. Over the years I have notched up skills in woodwork, hard landscaping, painting with oils, willow weaving, millinery and macramé. Still on my 'to learn' list are throwing pots,

blacksmithing and watercolour painting. Learning a craft is a thoroughly immersive thing: once in the grip of it, all else is forgotten as you focus on the task in hand. There are inevitable setbacks and moments of self-doubt along the way, but even if you make something that falls short of what you had hoped, you have still made it. Something exists because you have created it, and that is very cool indeed.

100 Browsing in a bookshop

How often have you wandered into a bookshop* in search of a particular title and left without it but with several unexpected purchases instead? This happens to me a great deal. I read a review of a book or a friend recommends one, I head off in search of it. I cannot find it but the helpful person at the till orders it for me. As I am now in the shop, I take a look around. New fiction titles are piled up enticingly by the door; they all look like essential reading. I choose one and pick it up, intending to buy it. Around the corner are gardening and cookery books. Flipping through one I see a delicious-sounding recipe. Should I recklessly buy that one as well? A quandary that is deepened when I drift over to the travel section and find a guidebook about somewhere I intend to visit. The shop is quiet, apart from the sound of pages being

riffled and hushed conversations. I remember the title of a classic I have yet to read and head off to find it. The smell of coffee reminds me that the bookshop has a café. I order one and sit down. Minutes pass comfortably. I leaf through my pile of planned – and unplanned – purchases. The coffee arrives. There is something immeasurably comforting about being tucked away, surrounded by shelves of books, absorbed in a new purchase. I could stay there all day.

* All the above applies equally to a library, except, of course, you don't have to pay for the books. And the coffee probably isn't as good, in all honesty.

First published in the United Kingdom in 2022
National Trust Books
43 Great Ormond Street
London
WC1N 3HZ

An imprint of Pavilion Books Company Ltd
Copyright © Pavilion Books Company Ltd 2022
Text copyright © Clare Gogerty 2022

ISBN 978-1-91165-742-2

A CIP catalogue record for this book is available
from the British Library.

10 9 8 7 6 5 4 3 2 1

Reproduction by Rival Colour Ltd, UK
Printed and bound by Toppan Leefung Ltd, China

This book can be ordered direct from the publisher at
www.pavilionbooks.com Also available at National Trust
shops or www.nationaltrustbooks.co.uk

Illustrations by Tom Frost